Bernd and Hilla Becher

Bernd and Hilla Becher

Basic Forms

With a text by Thierry de Duve

te Neues Publishing Company
New York

The essay by Thierry de Duve originally appeared in the spring of 1992
as 'Bernd et Hilla Becher ou la photographie monumentaire'
in *Les Cahiers du Musée national d'art moderne*, no. 39, pp. 118-29.

It was translated from the French by Gila Walker

Published in the USA and Canada
by te Neues Publishing Company, New York

Lithographs by: NovaConcept, Berlin
Typeset by Passavia, Passau
Printing and binding by EBS, Verona

ISBN 3-8238-1001-4
A Schirmer/Mosel Production

Contents

Thierry de Duve
Bernd and Hilla Becher or Monumentary Photography
7

Plates
23

List of Plates
153

Chronology
157

Selected Bibliography
159

Thierry de Duve

Bernd and Hilla Becher
or Monumentary Photography

My first is a series of pictures, my second a well-known Chinese proverb, my third an equally well-known quote from Shakespeare, my fourth a citation from Valéry, not quite as well known as my second and third. My whole is the article that you have just begun to read.

My first, then, is the series of pictures reproduced in this book. They were taken by the German artist twosome, Bernd and Hilla Becher, who have travelled throughout the industrialised world for more than thirty years, producing a photographic inventory of its buildings — its mine shafts, blast furnaces, cooling towers, water towers, gasometers, and so on, catalogued by functional criteria. The photos are taken with a technical camera, early in the morning, on overcast days, so as to eliminate shadow and distribute light evenly. The subject is centred and frontally framed, its parallel lines set on a plane as close to an architectural elevation as possible. No human beings and no clouds or birds in the sky interfere with the starkness[1]. Not a mood is conveyed in the image, not the slightest touch of fantasy disturbs its ascetic neutrality. Rarely has the refusal of *subjektive Fotografie* been taken so far, rarely has the *Sachlichkeit* of the camera lens been pursued in such a systematic way. If it were possible for photography to be totally devoid of style, the Bechers' would be so utterly. Their work belongs to the archival tradition of photography in which Atget and Sander – artists who made it a point of honour not to be 'art' photographers – excelled. The Bechers' pictures could be described as pure documents if there wasn't something that prevented us from placing them, without further ado, in the category of the documentary photo. This something will be discussed herein.

7

My second is the famous Chinese saying: 'When the wise man points to the moon, the fool looks at his finger.' In the case of Bernd and Hilla Becher's photos the fool looks at the photo and the wise man at what the photo shows. The fool asks why these pictures are 'art', while the wise man sees in them indisputable testimony to the real world. Yet the wisest of wise men is a fool to begin with because to know that the finger is pointing at the moon, he must first look at the finger. It is one of the paradoxes of photography that a swivel is ceaselessly swinging the viewer from a transitive to an aesthetic use of the picture and vice versa. But one of the characteristics of the Bechers' photography is that it stops the swivel at the moon not the finger. This too will be discussed herein.

My third is the quote from Shakespeare, 'What's in a name? That which we call a rose / By any other name would smell as sweet.'[2] Is this really true? In the case of Bernd and Hilla Becher's photos, nothing is less certain than the indifference of things and people to the names they are given. Even though the Bechers have a thorough knowledge of their photographic profession, it is difficult to call them photographers. In the art world where their work circulates, where it is seen and sold, people describe them as artists, occasionally adding 'who make use of photography'. When their œuvre received an award at the Venice Biennial in 1991, it was neither a photography award (there is none) nor one for art 'in general' (there is none yet); instead they were given the sculpture award, no doubt because one of their first collections of pictures was entitled *Anonyme Skulpturen*. Does that mean to say that they are sculptors? This question will also be discussed.

My fourth comes from Paul Valéry: 'Painting and Sculpture', says the demon of Explanation, 'are abandoned children. Their mother is dead, their mother Architecture.'[3]

The poor little ones have been placed in an institutional home, and Valéry was no less aware than Barnett Newman (who said

that sculpture was what you bumped into when stepping back to take a look at a painting) that whereas the museum is a relatively hospitable orphanage for painting, for sculpture it is one worthy of Comtesse de Ségur. And yet, thanks to the Bechers, a water tower is turned into a sculpture. Does it make any sense to say that this water tower has lost its mother architecture? These are the themes and the questions. Now let us play.

Let's go right to the essential. I love Bernd and Hilla Becher's work. It harbours so much contained emotion, melancholy without nostalgia, historical pain, class wars fought or sustained, wonderment at the engineer's protean art, lucidity, dignity, respect for things, humility and self-effacement that I have only one thing to say about it: this is genuinely great art, the kind that has no need to have its name protected by being placed in a museum, because it already belongs to our collective memory. I like the fact that there is something never-ending about the inventory that the Becher's have undertaken — because new buildings are always being built, because the job is vast and human life is short — and I like the fact that this Titanic enterprise has nothing of the Sisyphean dimension that characterises so many of the repetitive practices in contemporary art. I like the admirable reserve of the Bechers' photos, their unique way of being devoid of style, their formal uniformity. I like the fact that theirs is the modern aesthetic of fidelity to the medium and not the post-modern aesthetic of appropriation. I like the fact that this aesthetic is a moral principle and that it takes the intrinsic humbleness of photography to the pitch of incandescence. I like the fact that these photos always draw attention to what they show, never to themselves. I like the fact that they strive to make an inveterate gallery-goer like myself wise.

　Hung on the walls of a museum or gallery where they are 'art' or set on the pages of a book where they border on the ethnographic document, Bernd and Hilla's photos show themselves. But in both cases, because they are photos and not paintings or

etchings, they show themselves showing what they are showing. Just as it is inevitable for the finger to show itself pointing to the moon so that we see it making a pointing gesture, it is inherent to all photographs that they show themselves showing the thing that a light ray etched onto their surface. Charles Sanders Peirce classified photography as a sign by physical connection which, like smoke or footprints in the snow, is at once *indice* (the trace) of the object it refers to and *index* (the finger) pointing to it.[4] Such signs attest to the actual existence of their referents because they are related to them by a causal link which may operate in spatio-temporal contiguity (there's no smoke without fire) or in broken contiguity (the footprint is the fossil of the past). Some signs do not resemble their referents (such as smoke), the ones that do (such as footprints) figure in Peirce's classification as icons as well as *indices*.[5] Such is the case of photography. Take a photo of a water tower. The photo shows it, in the sense of representing it, and it shows it, in the sense of pointing to it. It represents it as would a drawing with one slight difference and that is that photochemical causality connects it point by point with *this* particular water tower and that this water tower must have existed at one time even if it does no longer. And it shows it as would an outstretched finger designating *this* water tower to the viewer, with one slight difference and that is that there is no water tower at the end of the finger. It is the photo that I see and yet the real water tower is somewhere, at the end of another outstretched finger, a linguistic one made of proper nouns (*Lübeck, D 1980*, for instance).

Obviously all photos work in this way, and faced with any photo the viewer is wise and foolish in turn. Wise to look at the moon and foolish to look at the finger; wise to understand that the moon is not at the end of the finger and yet dumb, dumbfounded by the reality of this *index* that resembles what it is pointing at; and yet again, wise to be attached to the specificity of this particular *index/indice*, and stupid to be chained to it. This is the swivel that is ceaselessly swinging the viewer from a transitive to

a reflexive use of the picture and vice versa. If he considers the photo as transparent and looks through it for evidence of the real world, then we say he sees it for its documentary value; but this value is something he obtains from the document in his hand from which the documented reality is already gone. And if he considers the photo as opaque and contemplates it for itself, then we say he sees it for its aesthetic value; but this value only pertains to the photo, as a photo, insofar as it attests to its dependence on reality. All photos, be they signed by Bernd and Hilla Becher or taken by you or me, embody the 'phenomenological and semiotic paradox' that stems directly from their nature as indexical icons.[6]

Why then, if the Bechers' photos do the same thing that all photos do, and especially if they do so in a purer way more faithful to the medium, why then are we reluctant to describe the couple as photographers? Aren't they eminently so? Do they not fit into the same tradition as Maxime Du Camp, Timothy O'Sullivan, Atget and Sander, for instance? Isn't what is outstanding about their photos precisely their way of not standing out, of not proclaiming an aesthetic or an artistic status? Isn't it their way of being simple 'documents for artists', like Atget's photos, rather than 'art photos'? It is and it isn't. The Bechers could be regarded as direct heirs to Atget if it were still possible to imagine them as naive, unconscious or instinctive in their use of the medium; if the pure instrumentality of their practice were not marred by reflexivity; if the place that John Szarkowski could have given them in his history of photography (seen in terms of the photographer's growing awareness of the medium's intrinsic characteristics and problems) had not already been taken, and a long time ago by Atget himself.[7] But the Bechers prevent this identification. Rightly or wrongly, they won their place in the history of contemporary art side by side with conceptual artists. The recognition they gained in *straight photography* circles came later and only after they were already known in a circle that considered them artists not photographers (and eventually, if pressed, artists 'who make use of photography'). They 'do' photography but they are not photo-

graphers. If we are to believe the Venice jury, they are sculptors. But the Bechers don't 'do' sculpture, they photograph it. And what they photograph is not sculpture, not until it has been photographed, not until the camera has been pointed at it, not until it has been framed out of context, not until it has been disconnected from its use and usefulness, not until it has been set down on bromide and prepared for aesthetic consumption and, finally, not until it has been entitled *Anonyme Skulpturen*. As we have seen, this is the title of one of their first collections of photos (a series of cooling towers and a series of mine shafts) whose subheading declares: *Eine Typologie technischer Bauten*. Thus the operation is made explicit: by means of photography, the Bechers bring to our attention 'industrial buildings', 'constructions', 'structures', 'objects' — What the devil are we to call them? — that form *a typology of technical buildings*, and that they call by the name of sculptures. Now, whether Shakespeare likes it or not, it is clear that these objects smell sweeter by their new name: they have the sweet fragrance of art.

These sculptures may have the sweet smell of art, but they are nonetheless *anonymous*. No one has signed them, no one has claimed authorship. The book is signed, but this simply means that Bernd and Hilla Becher have assumed responsibility as authors of the photos, nothing more. In naming the book *Anonyme Skulpturen*, they declare their eschewal of responsibility as authors of the sculptures that the photos contain and designate. I guess they feel they haven't the right, having neither designed nor produced these sculptures, which, however, would not exist as such without them and which, without photography, would merely be *technical constructions*. Sculptures they are, but authorless they will remain. In this the poor little ones share to a certain extent the sad fate of orphans that Valéry ascribed to sculpture in general.

But who has abandoned Painting and Sculpture? Their mother Architecture is dead, answered Valéry. Obviously, he was not thinking of *technical construction*, the kind that the Becher

photos show in a state of disuse if not dead. What he must have had in mind was Architecture with a capital A, the kind of sacred and legitimate theatre of power embodied by the Greek temple, the Gothic cathedral or the Renaissance palace. Being a great classicist with a keen sense of modernity, Valéry must have regretted its death only partially. I can readily picture him in the twenties talking about architecture with Walter Gropius, that great modernist with a keen sense of classicism. And I can picture Gropius responding: Painting and Sculpture are in the limbo of anonymity because their Mother Architecture has yet to be born. Valéry would have agreed.

Architecture dead, architecture yet to be born. Clearly it is not the same. To Valéry what was being built around him no longer deserved the name architecture, to Gropius it did not yet. Clearly, they are not the same constructions. In the meantime the name had become compromised, unfit and useless. I put it in Gropius's mouth as a retort to Valéry but Gropius would have superstitiously abstained from uttering it. The term that he used in real life was *der Bau*. An infinitely humbler term but charged with as much ambition as had been Architecture with a capital A. Witness the first sentence of the Bauhaus manifesto: *"Das Endziel aller bildnerischen Tätigkeit ist der Bau"*.[8] ("The final goal of all creative activity is *der Bau*", which ought to be trans-lated as 'construction,' 'building,' 'the built'.) To this *Bau* he erects a home — a school, not a museum — meant to foster and nurture the painting and sculpture of tomorrow. The orphans of today will grow up tomorrow in their mother's home when *der Bau* has recovered its name of Architecture, modern architecture.

Well, it has and long ago. It already had when Bernd and Hilla Becher at the end of the fifties began their *Typologie technischer Bauten*. To the expression 'modern architecture' it is easy to give as referents Gropius's own works and those of Breuer, Mies and Corbusier. They are as legitimate as the Greek temple, the Gothic cathedral or the Renaissance palace. But in 1922 when Corbusier

was looking for the path *Toward a New Architecture*, or in 1919 when Gropius founded the Bauhaus, what were their referents, what models did they cite for an architecture yet to be born? 'The most well known was taken from industrial and industrious America and celebrated by both Corbusier and Gropius: the grain silo. If you add warehouses, factories, ocean liners, bridges, water towers, cooling towers and gasometers, you'll soon have an entire *Typologie technischer Bauten*, composed of 'industrial buildings', 'constructions', 'structures' — What the devil are we to call all this anonymous architecture with no awareness of self? — that can be added in turn to Paxton's *Crystal Palace*, the Eiffel tower, Maillard's bridges and all the other signed engineering constructions that make up the prehistory of modern architecture, to provide a referent for the term *der Bau*.

In the Bechers' practice there is an element of immense affection for the *technische Bauten* that they photograph, and a clear desire for rehabilitation. Grain silos and water towers never attained the status of architecture, nor even that of signed engineering constructions. Modern architecture achieved legitimacy and success on their backs, if I may say so; the concept of *Bau* gained its status as architecture at the expense of its referents' anonymity. The Bechers give them back their dignity and it is with good reason that the two are seen as allies by those interested in preserving the industrial heritage. But it would be futile to look in their work for that somewhat sickening nostalgia, that retrospective idealising, that aestheticising of the past, and that fetishist romanticism that are like the signature of industrial archaeology. Futile again to look for a revisionist attempt to rewrite architectural history as it did not happen. Evidence thereof is the name of *sculptures* which they assign to the constructions they photograph. It gives them a fragrance of art, to be sure, but tainted; it shows them out of use, even when (as is often the case) they are still functioning; it refuses them the right to brandish the functionalist aesthetic as flag, ideology, utopia. If for Corbusier or Gropius it was too early in 1920 for a grain silo or water tower to deserve

the name architecture, for the Bechers it is too late. In the inter-
vening period, the functionalist aesthetic engendered the modern
idiom, the modern idiom became the international style, and the
City of Tomorrow failed at Sarcelles.[9]

All this is recorded in the art of the Bechers. Their art disre-
gards neither the success nor the failure of architectural modern-
ism. It speaks of its functionalist faith, its enthusiasm for
machines, its Promethean exaltation of technology but also of its
indifference to misery and its inability to look back and see the
damage caused. At the same time it keeps at a distance, or
somewhat removed, as if there were something indecent about
espousing a cause. This is not the art of Paul Strand or Renger-
Patsch, but neither is it that of Lewis Baltz or Robert Adams. In
the interminable inventory that the Bechers have undertaken it
is hard not to see a cruel portrait of all the most thoughtless,
unplanned constructions that industry has set in the environment,
those least concerned with beauty, least respectful of nature, and
least considerate of man. But it is just as hard to see it as a politi-
cal or ecological indictment. Maintaining the same distance from
regret as from denunciation, their work makes a modest observa-
tion.

Yet, the main feeling to which it gives rise — I mean to say,
of all the feelings it elicits in me, the one that is most lasting and
most insidious — is not at all what might be expected from a cold
observation. You'd have to be insensitive to the thoughtful care
with which the couple surrounds their photos — or sculptures —
not to feel all the respectful love that they bring to them. You'd
have to be blind to the profound motivation of their work not to
see that they eliminate all personal style from their photos — or
sculptures — only to better release the impersonal aesthetics.
Once you become sensitive to this, what comes is awe, the
pleasure of discovery, the joy of learning and comparing. To look
through a Becher book is to take a lesson in vernacular aesthet-
ics; it is to learn to read differences in composition, rhythm, and
formal solutions where an ordinarily distracted eye would see only

indifference and standardisation; it is to derive intense pleasure from your own capacity of discrimination; it is to suffer from your inability to back it up by a technical vocabulary that would make it possible for you to detail a gasometer's architecture as if it were a cathedral. To put it another way, it is to step back involuntarily, into the feelings and emotions that Corbusier and Gropius must have had at the time when the grain silo was emerging as the model for the architecture of tomorrow.

Involuntarily but not unknowingly. Impressed I may feel but fooled I am not; the Bechers won't let me be. I know that my feelings take me on a trip back in history and if I know my history I also know that it didn't fulfil its promises. It was because Architecture with a capital A was dead that the engineer momentarily replaced the architect. Modern architecture drew on the engineer's art but did not, for that matter, recover its place; the Bauhaus did not succeed in becoming the the house of the Bau where painting and sculpture would find a new home; and grain silos or water towers are still not architecture. Thanks to the Bechers, though, I have seen, studied and contemplated them as if they were. In this fully conscious 'as if' lodges a jubilation more secret than awe, something like a lucid innocence, the awareness of rediscovering intact, and without having to betray it, an ideal, even if it is tarnished. Often it occurs to me that the most important task for art and culture at the end of this century is to find the means of rediscovering a certain innocence, but an innocence after the loss of virginity, after the disenchantment and after the irony. And to me it is always a source of profound reflection to come upon a work that promises nothing but that elicits, as I have said about Duchamp's urinal, an unprecedented feeling, the kind of jubilation that turns modernity's project inside out like a glove, the kind of paradoxical future that is opened through a deliberately retrospective gaze.[10]

Bernd and Hilla Becher's œuvre counts among such works. It does not disregard a modernity which, in architecture as in other

fields where art and politics meet, began by celebrating a brighter future and is ending or exhausting itself in the disenchantment of 'post-modernism'. But it takes us back to the place where the utopia of modern architecture began and where, even though it failed in Sarcelles, the City of Tomorrow still harbours the recollection of utopia. It takes us back to the wonderment that Corbusier and Gropius felt, and Van de Velde, Muthesius, Behrens, Loos and Sullivan before them, at the aesthetic that was present in the constructions of engineers – immanent, unwitting, unconscious perhaps, in any case not thought out. It takes us back, then, to the sources of modern architecture.

It is the vocabulary of architecture, the forms and criteria of architecture, the history and the memory of architecture that the Bechers' photos evoke and convoke. It is not the vocabulary, forms or history of sculpture. Yet, oddly enough, it is thanks to a name change that the journey back to the sources of modern architecture on which the Bechers invite us becomes a real source of renewal rather than regression. It is thanks to the term *sculptures* that the Bechers attribute to the grain silo and water tower; it is thanks to the fragrance of art with which this name surrounds them and which shows them in disuse; thanks to the way it refuses them the possibility of displaying the functionalist aesthetic as a utopia that I can look at the photos as if they were architecture and as if I were Corbusier or Gropius discovering their beauty.

This name, sculpture, is not however the last word of the Bechers' art. It is there but only accompanied by the qualifier 'anonymous', as if to remind us that sculpture remains an orphan. It has been given a home by a stepmother whose name is photography. Hers is a more hospitable home than the museum orphanage; this at least is what more than one sculptor must have thought, Brancusi to start. But she is merely a foster mother: she has the power neither to conceive nor to engender, but only to take care of what already exists. With Bernd and Hilla Becher, she pushes her humility to the pitch of presenting herself as a simple

observation, document or record. Like the wise man in the Chinese saying, she urges the spectator to look at the finger for the moon and not the finger for the finger. Far from taking the reflexivity of the photographic medium and withdrawing into self-reference, as does a good part of the conceptual art with which it has been mistakenly associated, the Bechers' art puts to moral use the swivel that swings the viewer from a transitive to an aesthetic use of the picture and vice versa. They make sure that there is a world at the end of the finger, a world that is the world outside all right, the one where people live and die, love and work, but which is, however, nothing but the photographic world.[11]

To situate the world that has given a home to the Bechers' anonymous sculptures outside the photographic world is meaningless, since nothing outside identifies them as sculptures. Yet it is there, outside, that they exist and that, once they have been welcomed into the photographic world, they exist as sculptures. That a mine shaft exists in the Ruhrgebiet and another in Pennsylvania is evidenced by the album. The documents are there to prove their existence. But even if the album did not bear the title *Anonyme Skulpturen* (a title that the Bechers used only once, no doubt as a quip), it would be clear that it does more: it pulls these mine shafts from a state of derelict neglect and raises them to the rank of authentic monuments. Obviously they are monuments out there where they are, in the Ruhrgebiet or in Pennsylvania, but they owe this status to the photographic document alone. Conversely, having been photographed does not, in and of itself, confer upon them any monumentality out there where they are that they did not already have. We cannot succeed in describing the specific operation to which the Bechers subject the buildings that they inventory if we consider that they use photography as a strictly documentary genre to bring out an unobserved monumental quality that already exists in the real world. But we succeed no better if we think that photography imparts to their sculpture a conceptual or institutional status of monumentality.

At the cost of a neologism, we may perhaps be better off saying that the Bechers have invented the *monumentary* genre in photography.

I wouldn't be so bold as to swear that it is their invention, even though I can't think of any other practitioners of the genre besides their students. And I'd be even less inclined to vouch for it as a genre, even though the documentary exists as a genre. I think of it more like a case that applies to photography alone and only insofar as photography is the mother of sculpture – or rather the stepmother. The monumentary is to monumental what the documentary is to the real world in general. In the monumentary case, the monumentalization is never actually effective but it is never merely conferred as a nominal status either. In other words, it is neither on the order of the real nor solely at the order of the symbolic; it affects the referent, namely the real as long as it is designated by the symbolic (the moon as long as it is at the end of the finger; the world as long as it is photographic).

More than an aesthetic genre, the monumentary case in the Bechers' output is a moral code. A puritan code, to be sure, and which won't suffer irony, but a code that I personally feel is a historical necessity at a time when irony — that romantic and hence modern weapon par excellence — has lost its edge by being used excessively only to attack the small incestuous world of art.[12] And their ethical code has its aesthetic marks. Any photograph — especially private or official portraits, group or family photos, souvenir albums or history books, in short all photography understood as 'pose' — turns the people and things photographed into personal, familial or social monuments.[13] We say that such a picture immortalises the event, which actually means just the opposite: what it really does is declares its death and presents itself as a substitute object to help in the mourning. Such monuments, big or small, are called *Denkmäler* in German, memorials in English. Now, I find this memorial dimension strangely missing from the Bechers' photos. Even abandoned and half in ruins, these buildings are alive. The images that the

Bechers give of them are not meant to help us get over their loss. Conversely, even new and functioning, these buildings are already gone. The life in the images that the Bechers give of them is no longer their life on earth. It is as if they required an act of faith from us, a faith that compels admiration, even if we don't share it. They don't spare us the pain of mourning, but they ask us to practice joy in the face of death. This is not the joy of which Bataille speaks, but the joy that Bach's music conveys. There is a touch of Bach in the Bechers' art, and German culture has never produced anything better.

Notes

1 There are exceptions. As usual, they only confirm the rule and prevent it from lapsing into dogma.

2 William Shakespeare, *Romeo and Juliet*, Act II, scene 2.

3 Paul Valéry, 'Le Problème des musées', *Pièces sur l'art,* in *Œuvres*, volume II, Paris, La Pléiade, 1960, p. 1293.

4 [The notion of indexicality split into the untranslatable opposition between *indice* and *index* is influenced by Peirce but not directly derived from him. It corresponds neither to Peirce's triadic distinction between icon (a sign related to its object through some type of resemblance, such as a map), index (a sign related to its object through causal interaction, such as a footprint) and symbol (a sign related to its object via convention, such as words) nor to the other trichotomies developed in Peirce's writings. To maintain the author's distinction in this article between *indice* as trace and *index* as the pointer, i.e. the index finger, the terms will be kept when necessary in italics in the original French – Trans.]. See Charles Sanders Peirce, *Collected Papers*, vol. 1, book II, Cambridge, Massachusetts, Harvard University Press, p. 159. For an analogous (albeit fundamentally divergent) interpretation of photography as *indice* and *index* (a distinction that the English word 'index' does not render), see Daniel Soutif, 'De l'indice à l'index, ou de la photographie au musée', *Cahiers du Musée national d'art moderne* no. 35, Spring, 1991. To my knowledge Henri van Lier (*Philosophie de la photographie, Les Cahiers de la photographie*, Paris, 1991) was the first to make intelligent use of the semantic distinction between the *indice* and the *index* as regards photography which he sees as an *indice indexé*.

5 [Peirce uses the term index – Trans.]

6 Thierry de Duve, 'Pose et instantané, ou le paradoxe photographique', in *Essais datés, 1974-1986*, Paris, La Différence, 1987, p. 3.

7 John Szarkowski, *The Photographer's Eye*, New York, The Museum of Modern Art, 1964.

8 Cited in Hans M. Wingler, *The Bauhaus*, Cambridge, Massachusetts, MIT Press, 1969, p. 31.

9 [Sarcelles was one of the modern, sanitised and standardised new cities of public housing built in France in the fifties. It is synonymous with bad architecture – Trans.]

10 Thierry de Duve, *Au nom de l'art*, Paris, Minuit, 1989, p. 64.

11 To speak of a photographic world is to speak of a mode of existence proper to photography in which a world is posited precisely under the sole modality of its existence. Photography is chained to the existing world. It has no power to show a possible world or for that matter an impossible one, no more than it has the power to show that the world it is showing is necessary or that it is contingent.

12 A counter example will enable me to suggest in what way the refusal of irony characterises the *monumentary* as a moral code. What informs Robert Smithson's photographic essay *A Tour of the Monuments of Passaic, New Jersey* is not the monumentary but rather the monumental through derision. This wonderfully scathing work of great philosophical

21

complexity has its own ethics. But by visiting like a tourist the depressing industrial wastelands around the Passaic River in New Jersey and taking pictures of such 'monuments' as a bridge, a sand-pit and a manhole, Smithson was clearly conferring upon them the purely nominal status of monu-mentality. The irony is essential to the fact that the nominal status is perceived as an effective monu-mentalization, without which the derision would not work.

13 Cf. Thierry de Duve, op. cit. note 5.

Plates

The selection of the photos in this book is based on an exhibition showing the thematic range of the Bechers' work. For one year, from 14 December 1989 to 30 December 1990, the sixty-four photos reproduced in this book were hung in five rooms at the Dia Center for the Arts in New York City. The format of the bromine-silver prints produced by the artists themselves was 60 x 50 cm (23 5/8 x 19 3/4 inches). The pictures in the exhibition were displayed according to the sequence given on the floor plan of the gallery (see page 152). The date given in each caption refers to the year the photo was taken.

1
Kühlturm. Cooling Tower. Tour de réfrigération
Stahlwerk, Ebbw Vale, South Wales, GB 1966

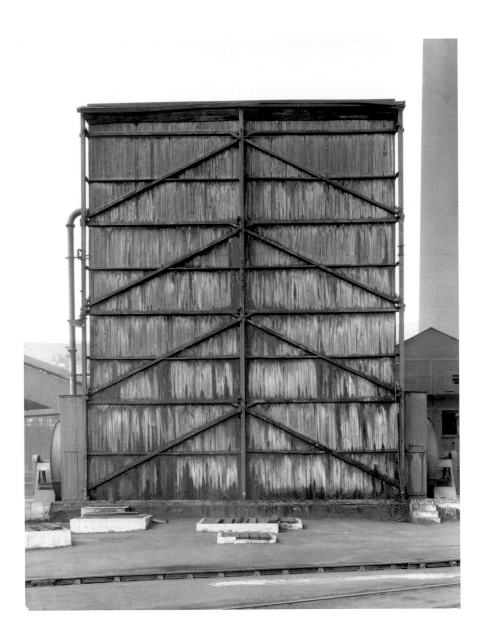

2
Kühlturm. Cooling Tower. Tour de réfrigération
Zeche Auguste Victoria, Marl, Ruhr, D 1967

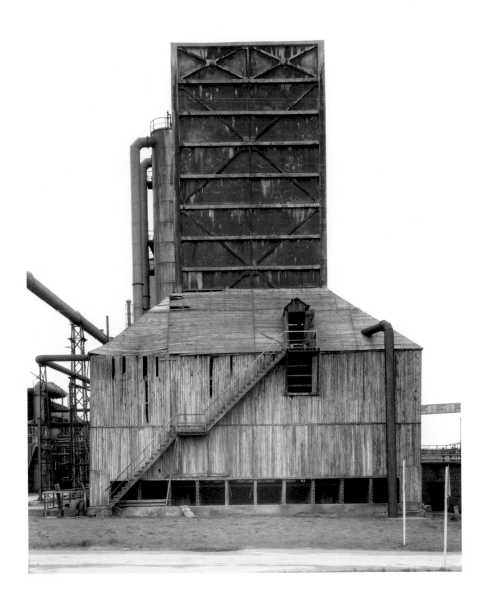

3
Kühlturm. Cooling Tower. Tour de réfrigération
Stahlwerk, Hagen-Haspe, D 1969

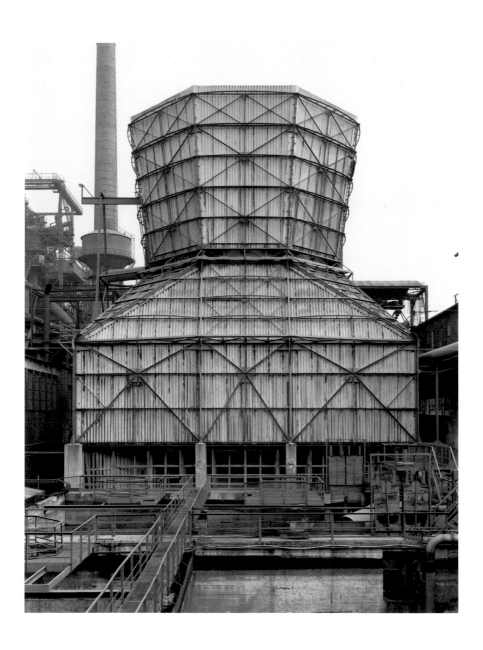

4
Kühlturm. Cooling Tower. Tour de réfrigération
Zeche Schalker Verein, Gelsenkirchen, Ruhr, D 1982

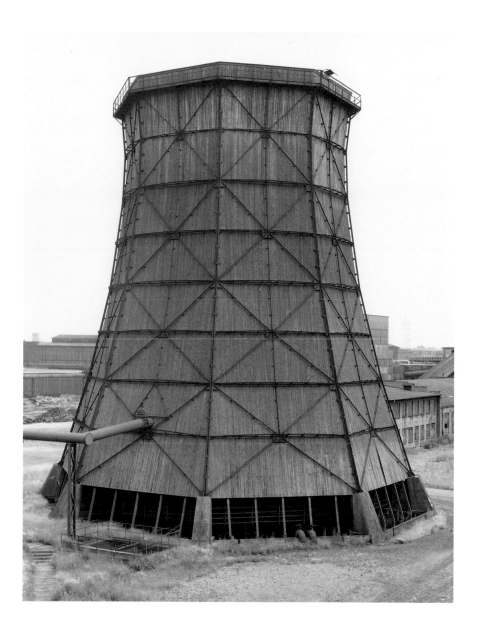

5
Kühlturm. Cooling Tower. Tour de réfrigération
Mons, Borinage, B 1967

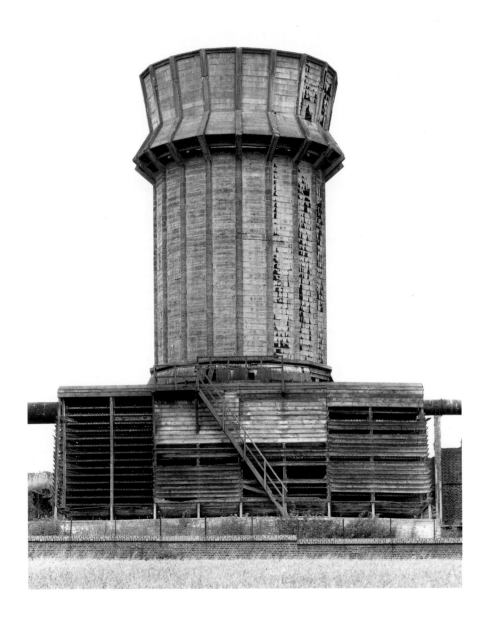

6

Kühlturm. Cooling Tower. Tour de réfrigération
Neunkirchen, Saar, D 1979

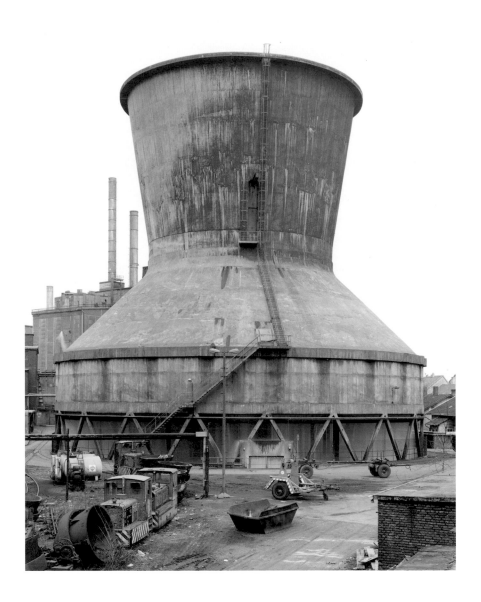

7
Kühlturm. Cooling Tower. Tour de réfrigération
Zeche Ewald Fortsetzung, Ruhr, D 1985

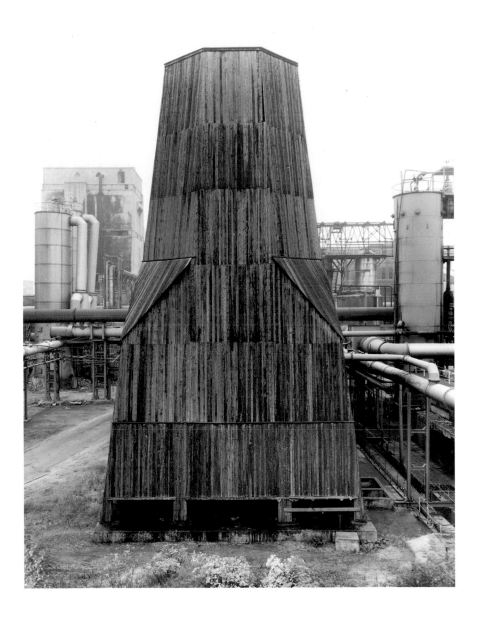

8

Kühlturm. Cooling Tower. Tour de réfrigération
Zeche Mont Cenis, Herne, Ruhr, D 1965

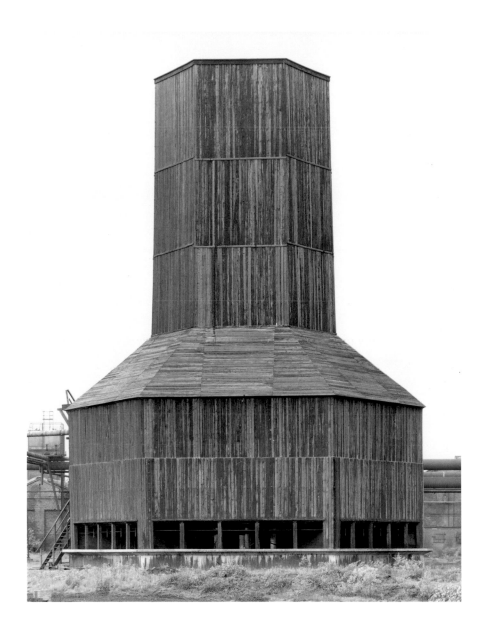

9
Kühlturm. Cooling Tower. Tour de réfrigération
Penallta Colliery, Caerphilly, South Wales, GB 1966

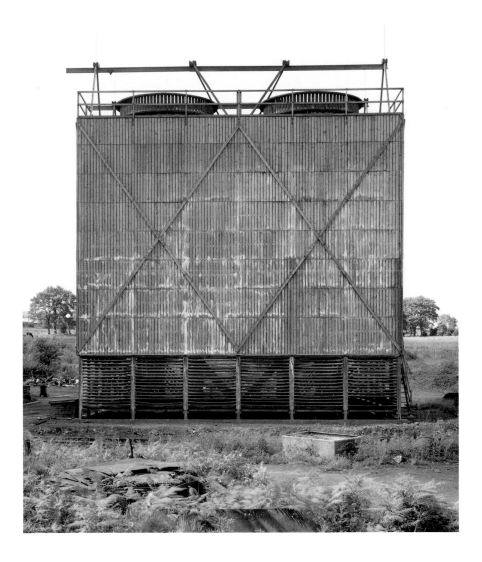

10
Kühlturm. Cooling Tower. Tour de réfrigération
Zeche Concordia, Oberhausen, Ruhr, D 1967

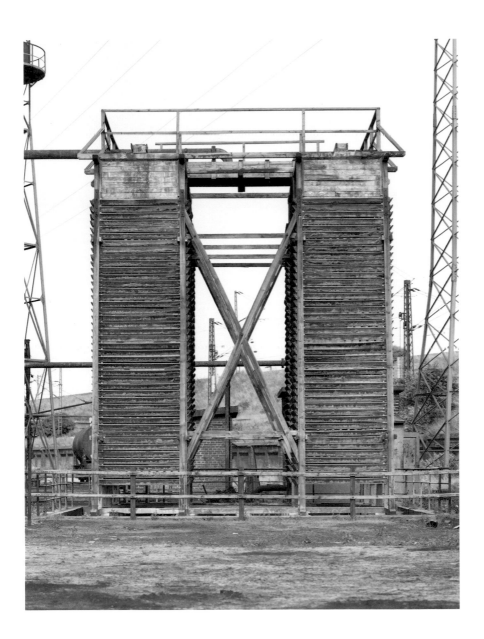

11
Hochofen. Blast Furnace. Haut fourneau
Youngstown, Ohio, USA 1981

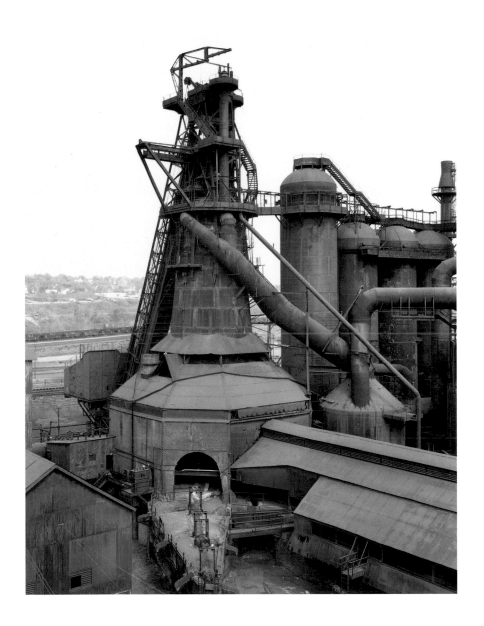

12
Hochofen. Blast Furnace. Haut fourneau
Ensley, Alabama, USA 1983

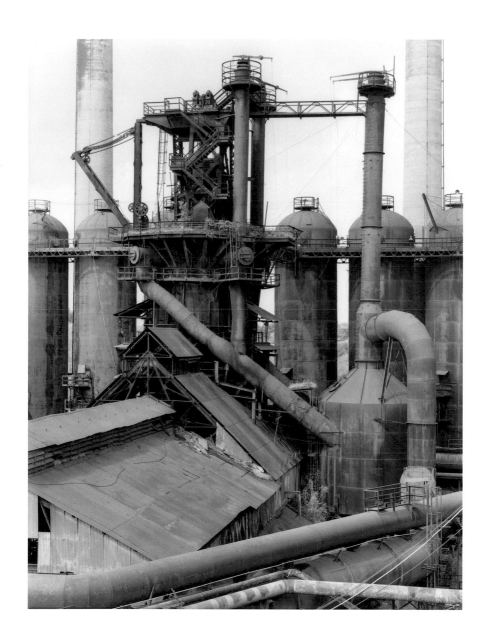

13
Hochofen. Blast Furnace. Haut fourneau
Johnstown, Pennsylvania, USA 1980

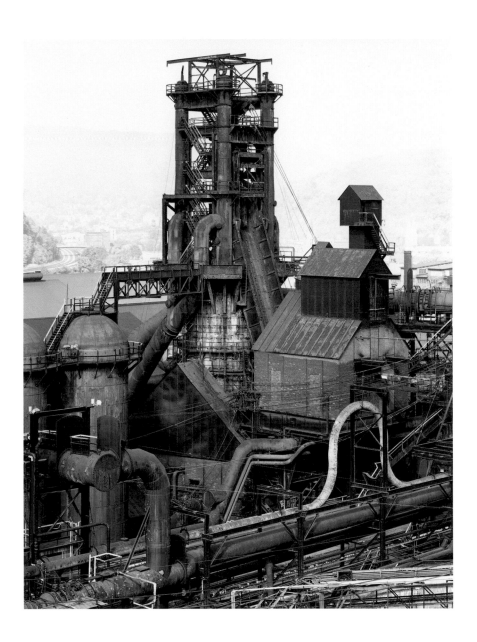

14
Hochofen. Blast Furnace. Haut fourneau
Cleveland, Ohio, USA 1986

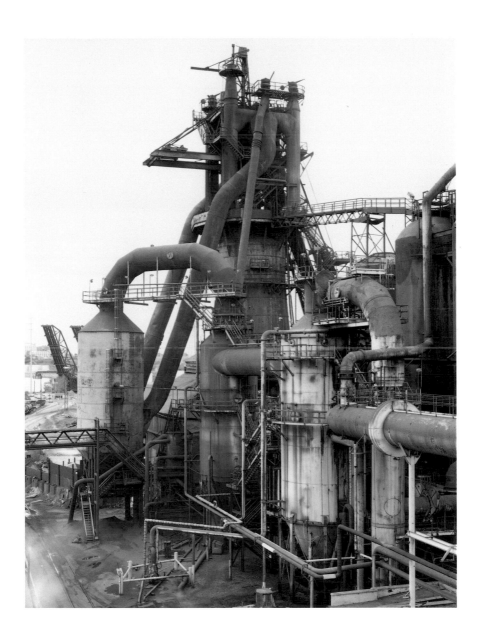

15
Hochofen. Blast Furnace. Haut fourneau
Dillingen, Saar, D 1987

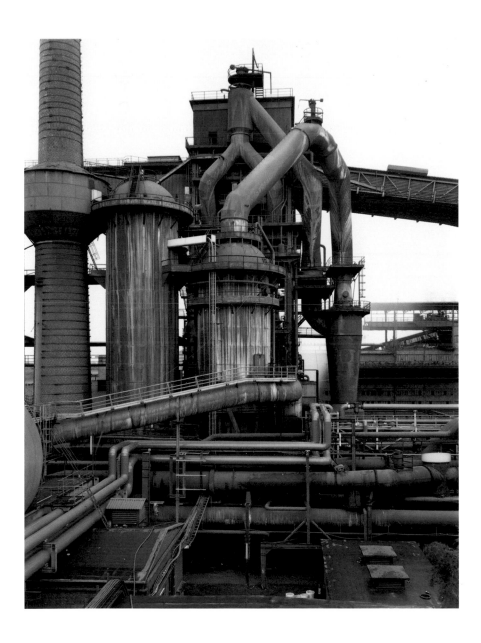

16
Hochofen. Blast Furnace. Haut fourneau
Rombas, Lorraine, F 1984

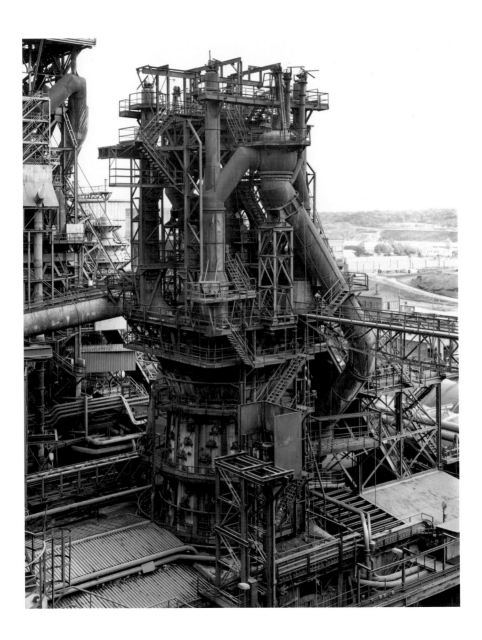

17
Hochofen. Blast Furnace. Haut fourneau
Rombas, Lorraine, F 1984

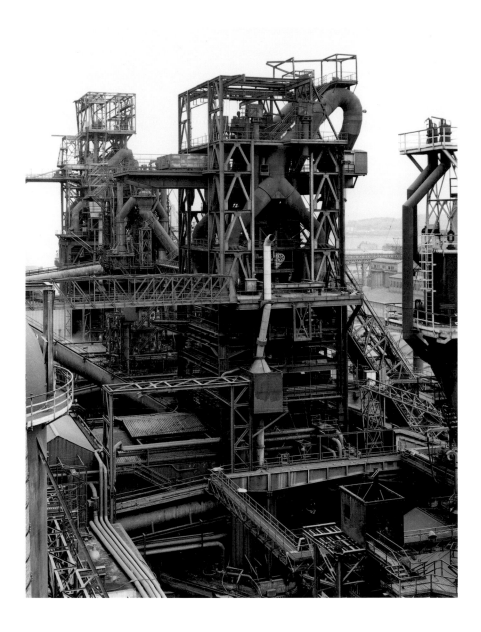

18
Hochofen. Blast Furnace. Haut fourneau
Rombas, Lorraine, F 1984

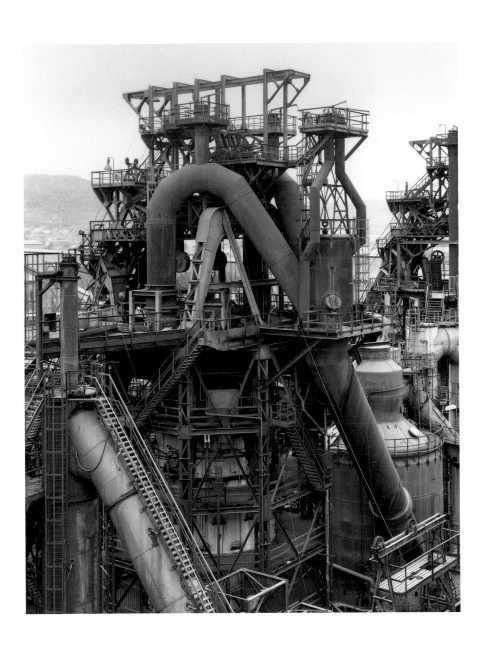

19
Hochofen. Blast Furnace. Haut fourneau
Boel, La Louvière, B 1985

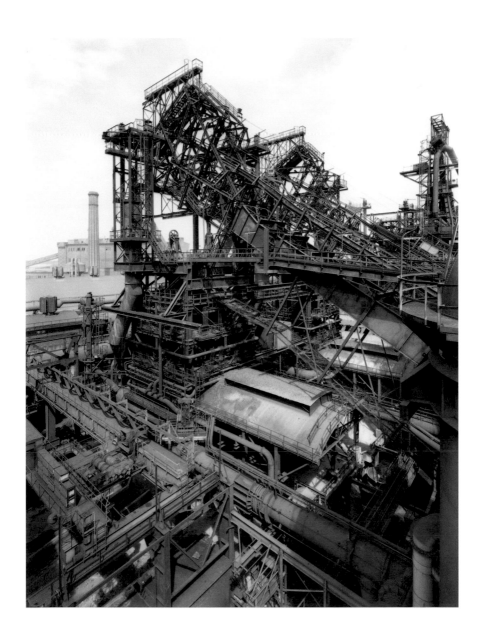

20
Hochofen. Blast Furnace. Haut fourneau
Boel, La Louvière, B 1985

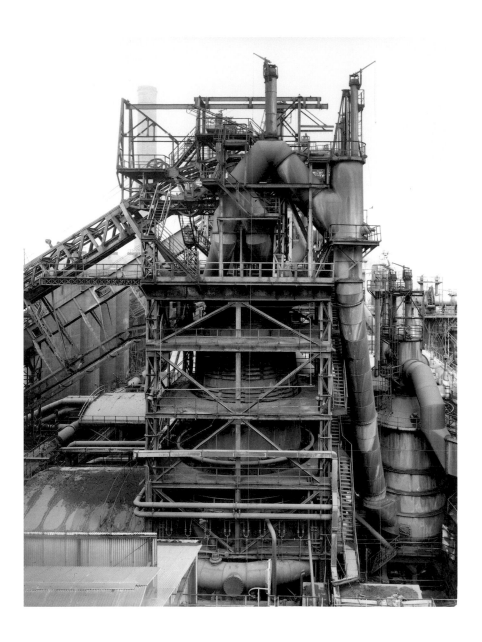

21
Hochofen. Blast Furnace. Haut fourneau
Terre Rouge, Esch Alzette, L 1979

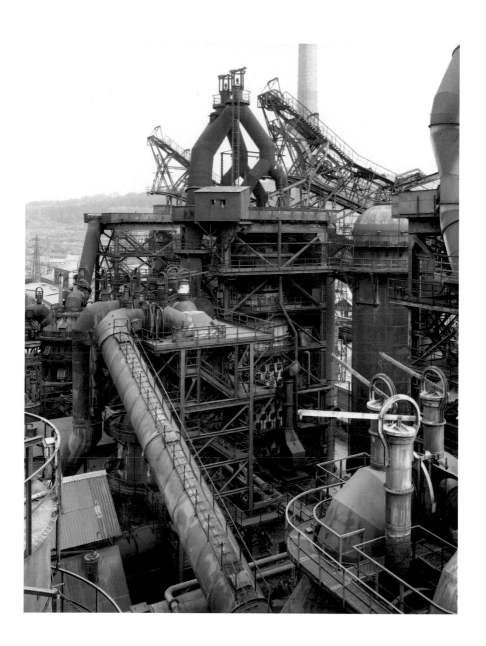

22
Hochofen. Blast Furnace. Haut fourneau
Völklingen, Saar, D 1986
I

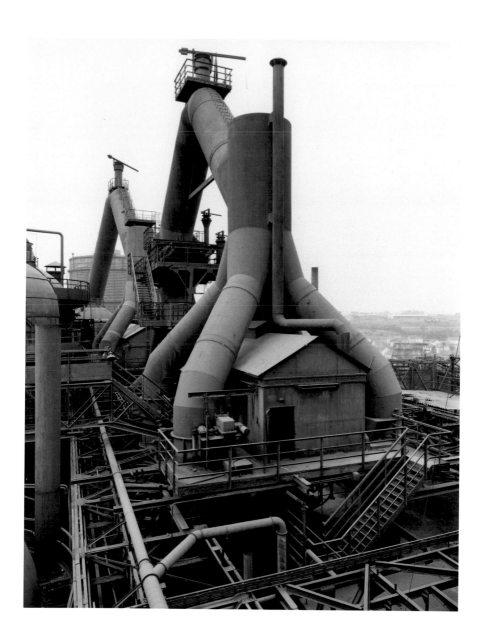

23
Hochofen. Blast Furnace. Haut fourneau
Völklingen, Saar, D 1986
II

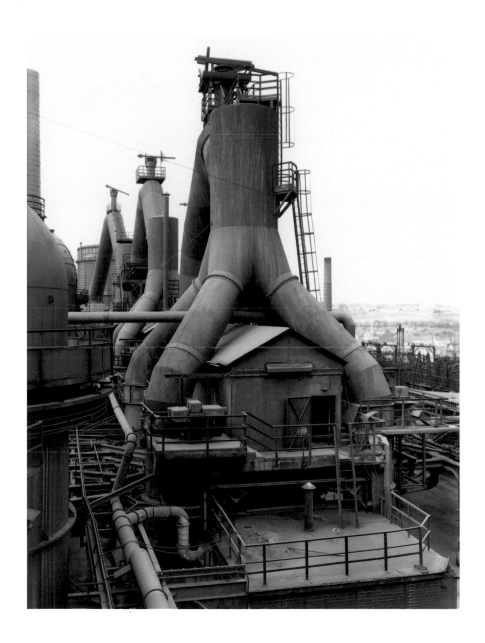

24
Hochofen. Blast Furnace. Haut fourneau
Völklingen, Saar, D 1986
III

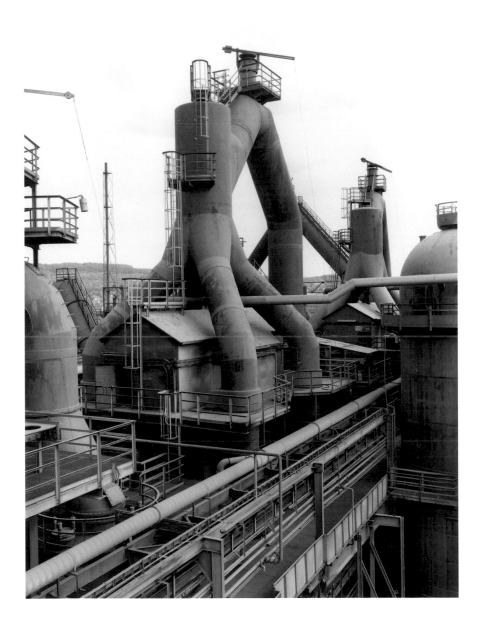

25

Hochofen. Blast Furnace. Haut fourneau

Völklingen, Saar, D 1986

IV

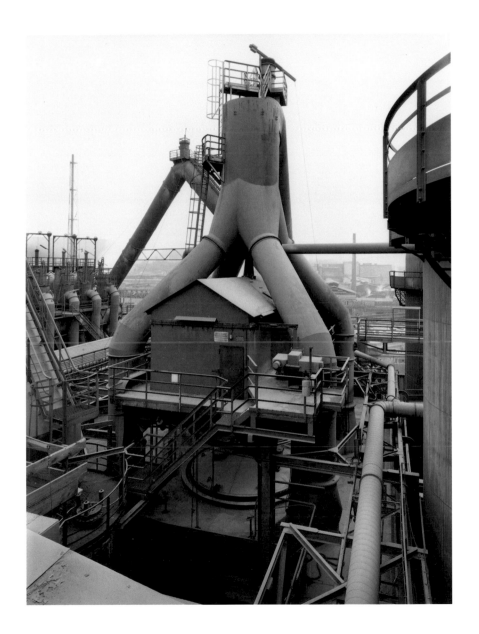

26

Förderturm. Minehead. Chevalement

Puits Lens No. 7, Wingles, F 1967

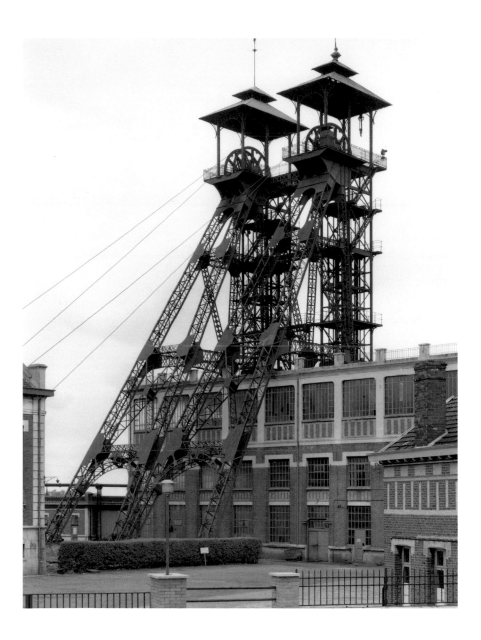

27
Förderturm. Minehead. Chevalement
Zeche Waltrop, Waltrop, Ruhr, D 1982

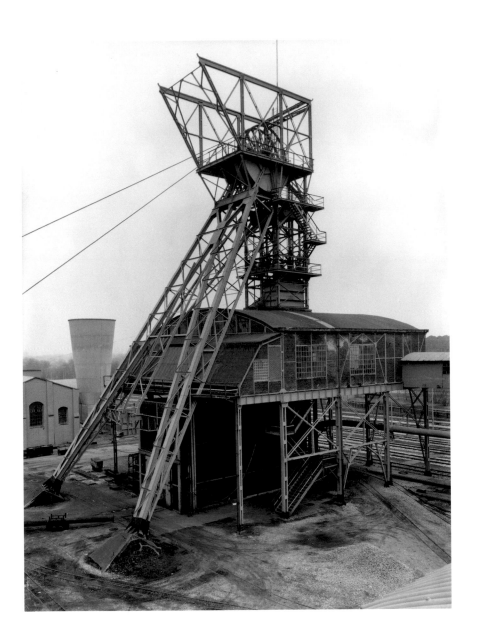

28
Förderturm. Minehead. Chevalement
Ryhope Colliery, Sunderland, GB 1968

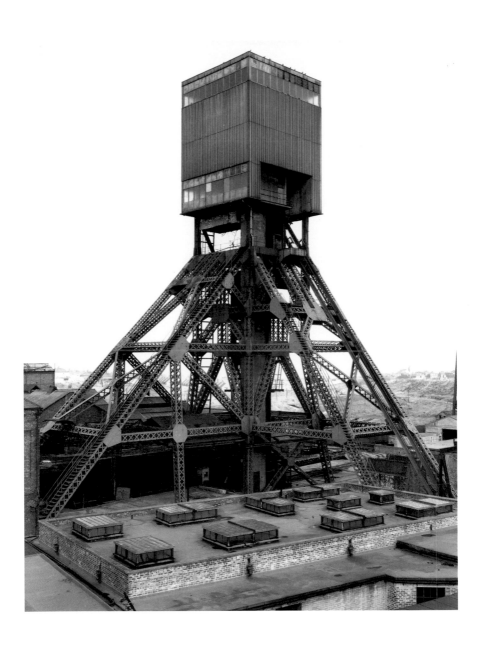

29
Förderturm. Minehead. Chevalement
Zimmerman Coal Co., Ravine, Pennsylvania, USA 1978

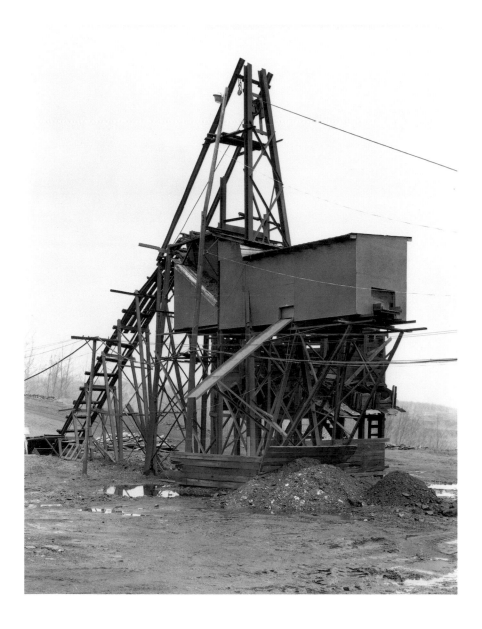

30

Förderturm. Minehead. Chevalement
Copperhill Mine, Central Shaft, Ducktown, Tennessee, USA 1983

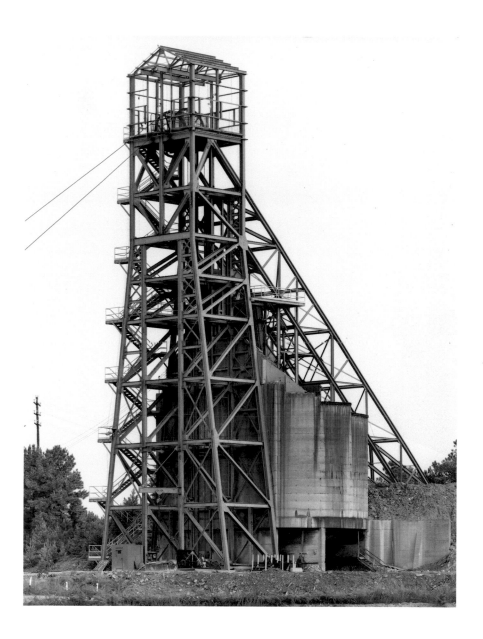

31
Winderhitzer. Hot Blast Stoves. Cowpers
Stahlwerk, Ilseder Hütte, Hannover, D 1984

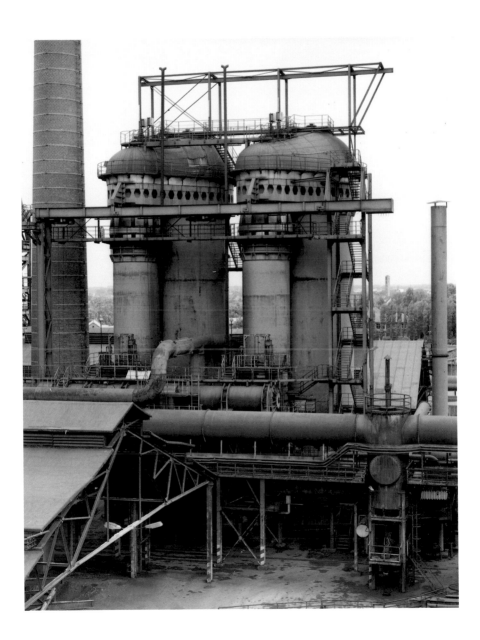

32
Winderhitzer. Hot Blast Stoves. Cowpers
Stahlwerk, Duisburg-Meiderich, D 1986

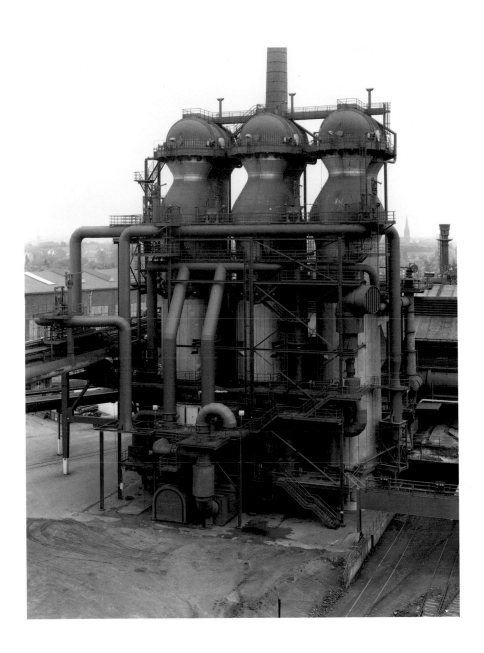

33
Winderhitzer. Hot Blast Stoves. Cowpers
Stahlwerk, Duisburg-Meiderich, D 1986

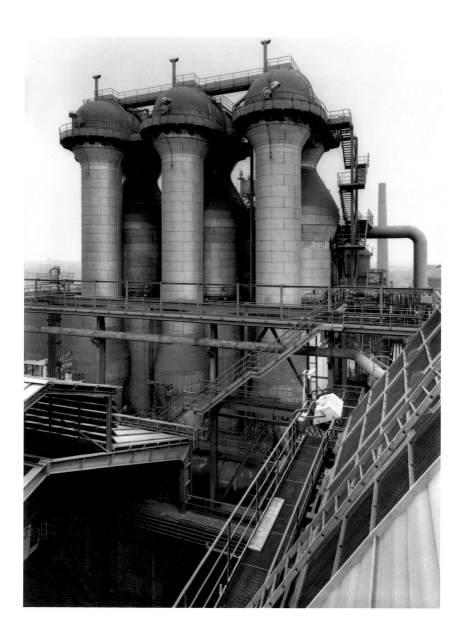

34
Kugel-Gasbehälter. Spherical Gas Tank. Gazomètre sphérique
Wesseling, Köln, D 1983

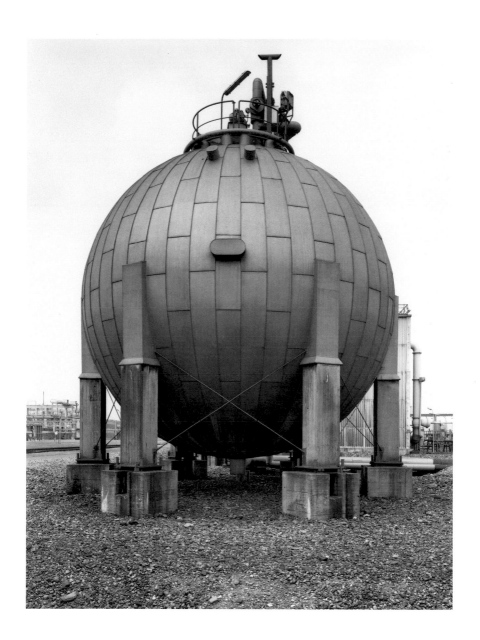

35
Kugel-Gasbehälter. Spherical Gas Tank. Gazomètre sphérique
Wesseling, Köln, D 1983

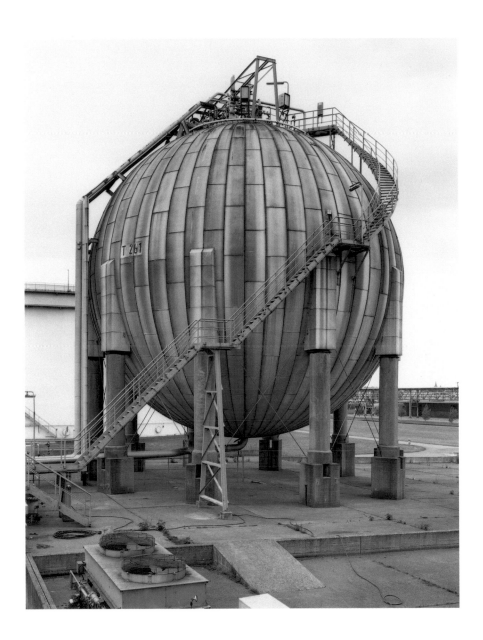

36
Kugel-Gasbehälter. Spherical Gas Tank. Gazomètre sphérique
Wesseling, Köln, D 1983

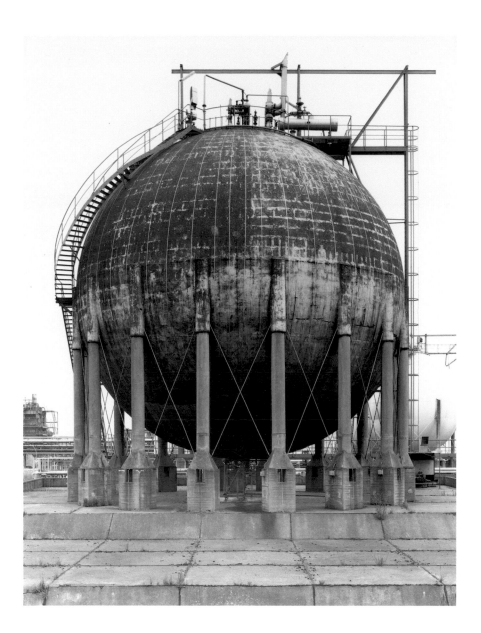

37
Teleskop-Gasbehälter. Multiple-section Gas Tank. Gazomètre télescopique
Pulaski Bridge, Jersey City, New Jersey, USA 1981

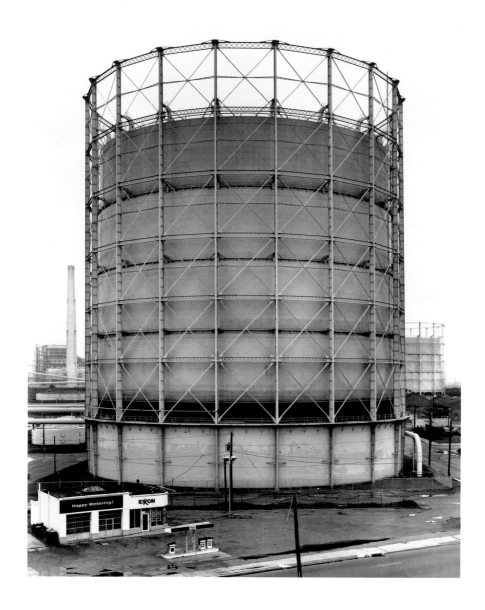

38
Schrauben-Gasbehälter. Spiral-guided Gas Tank. Gazomètre hélicoïdal
Tonyrefail, South Wales, GB 1973

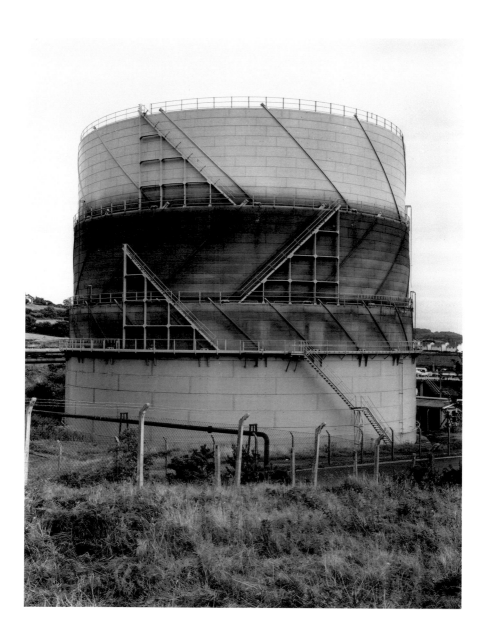

39
Scheiben-Gasbehälter. Piston-type Gas Tank. Gazomètre sec
Zeche Minister Stein, Dortmund, D 1987

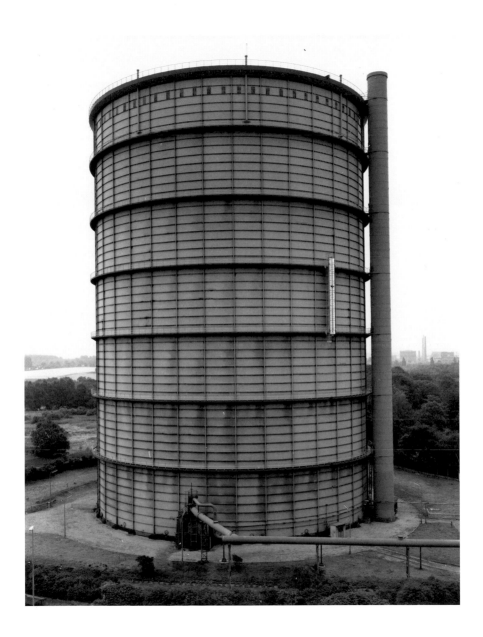

40
Getreidesilo. Grain Elevator. Silo à céréales
Van Wert, Ohio, USA 1977

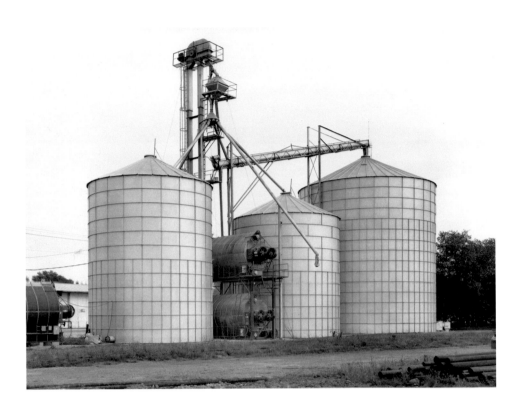

41
Getreidesilo. Grain Elevator. Silo à céréales
Van Wert, Ohio, USA 1979

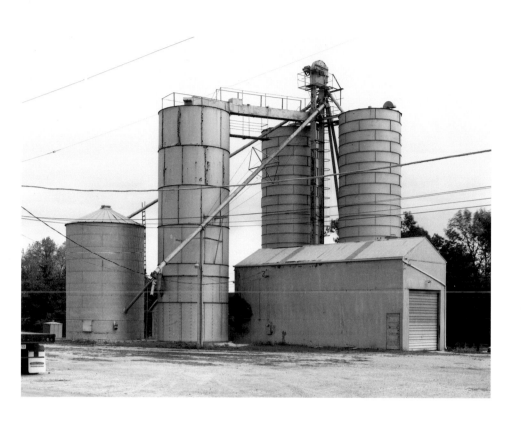

42
Getreidesilo. Grain Elevator. Silo à céréales
Lowell, Indiana, USA 1983

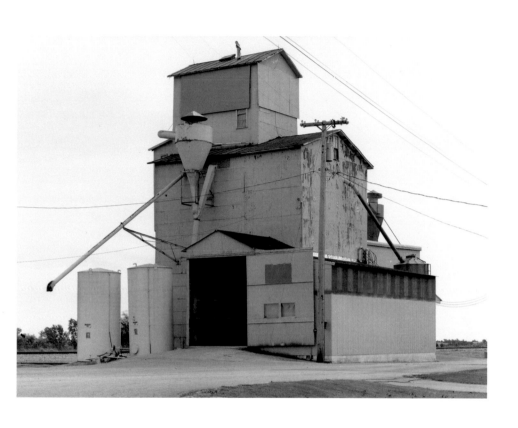

43

Getreidesilo. Grain Elevator. Silo à céréales
Wooster, Ohio, USA 1987

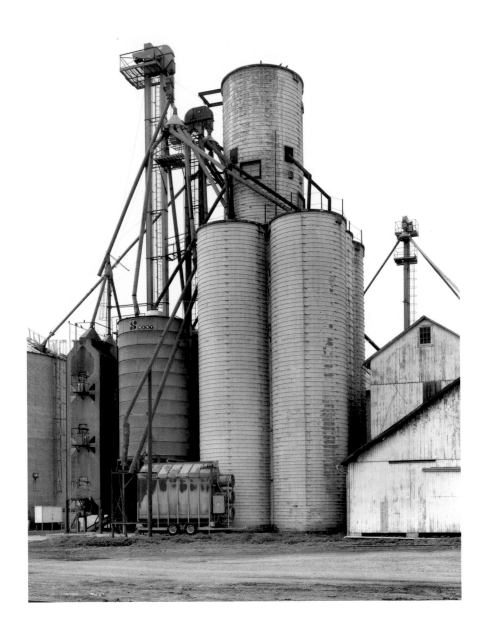

44
Getreidesilo. Grain Elevator. Silo à céréales
Bluffton, Ohio, USA 1987

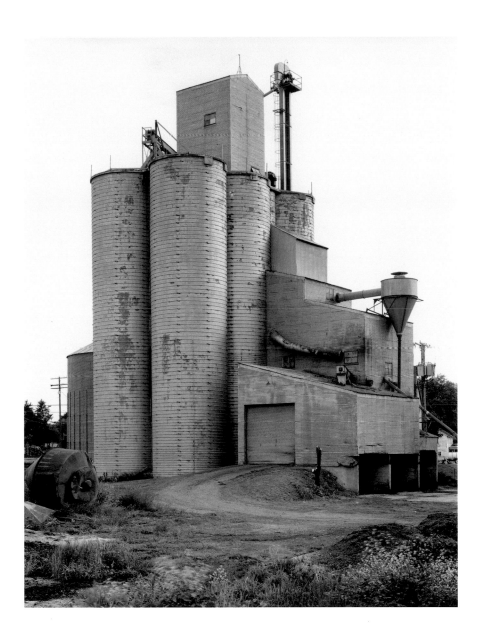

45
Getreidesilo. Grain Elevator. Silo à céréales
Bluffton, Ohio, USA 1987

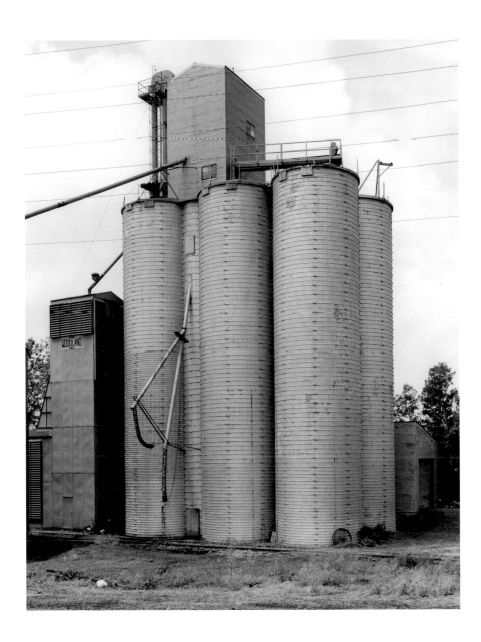

46
Getreidesilo. Grain Elevator. Silo à céréales
Smithville, Ohio, USA 1987

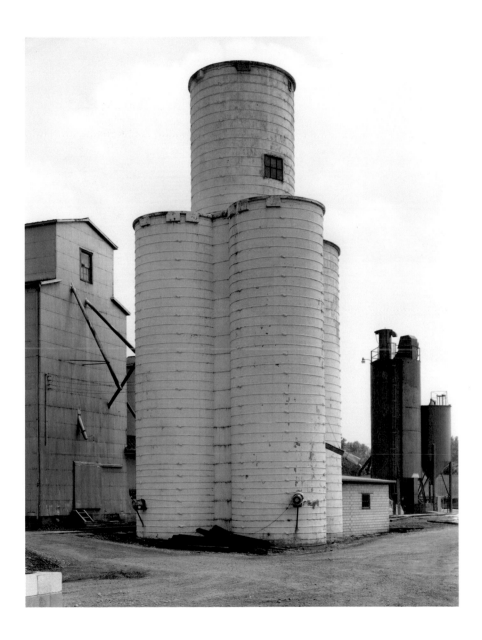

47

Getreidesilo. Grain Elevator. Silo à céréales

Elliott, Illinois, USA 1983

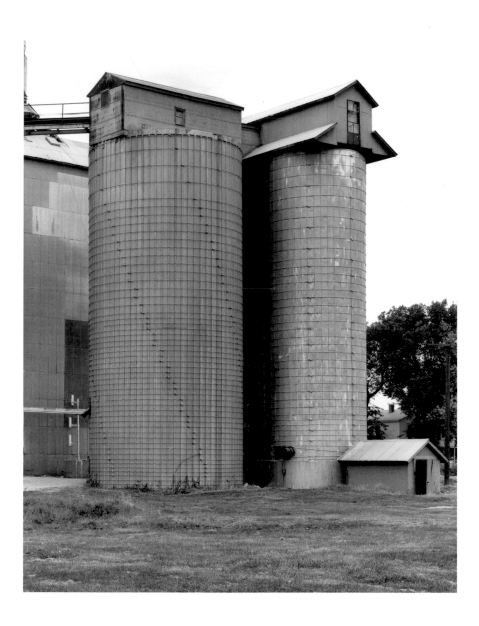

48

Getreidesilo. Grain Elevator. Silo à céréales
Strasbourg, F 1989

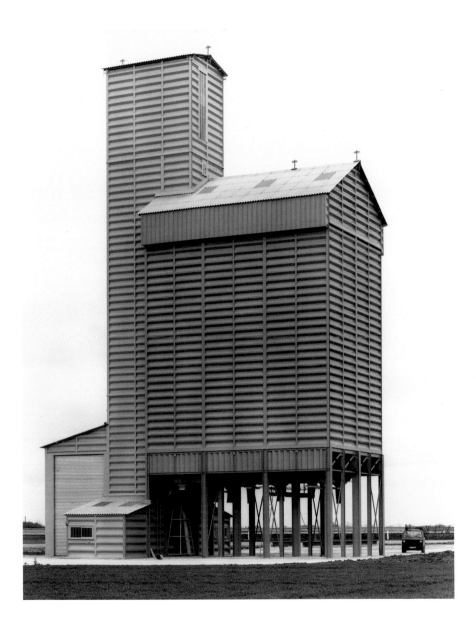

49

Getreidesilo. Grain Elevator. Silo à céréales
Briey, Lorraine, F 1985

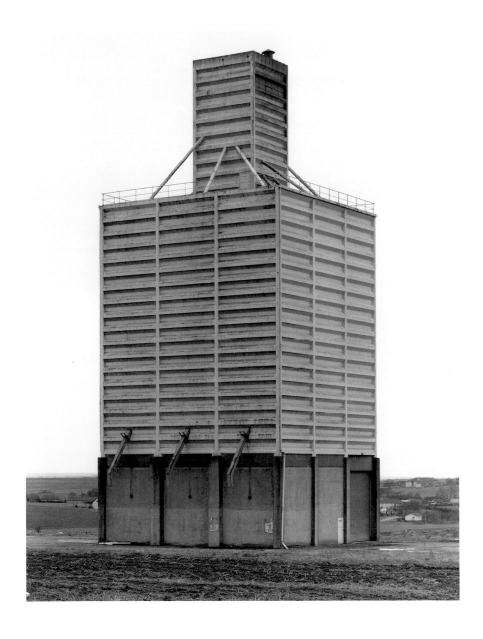

50
Steinbrecher für Basalt. Stone Breaker for Basalt. Concasseur de basalte
Mayen, Eifel, D 1987

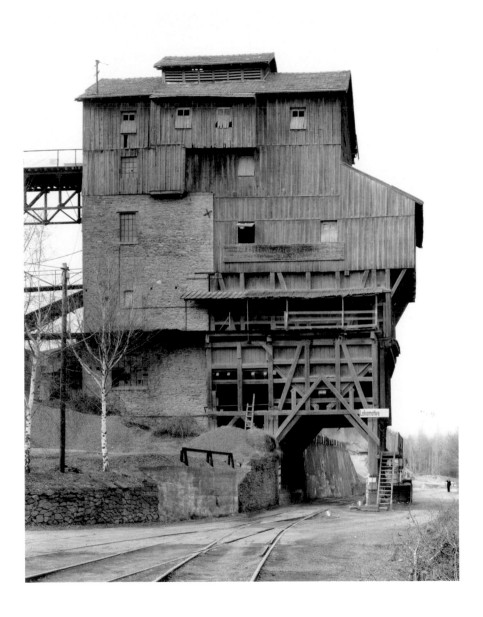

51
Steinbrecher für Basalt. Stone Breaker for Basalt. Concasseur de basalte
Nisterberg, D 1987

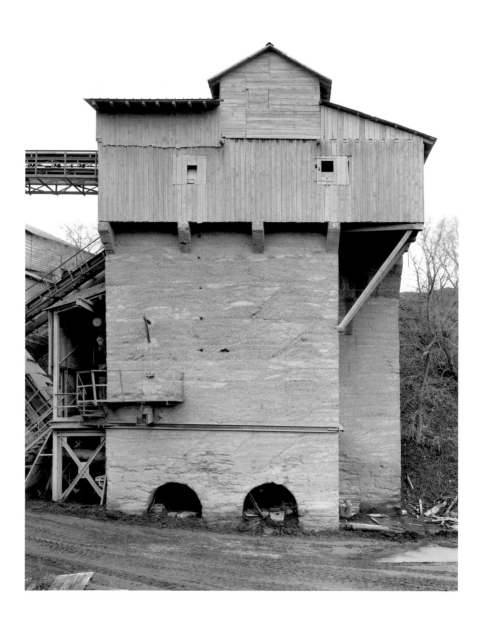

52
Steinbrecher für Basalt. Stone Breaker for Basalt. Concasseur de basalte
Schwäbisch Hall, D 1989

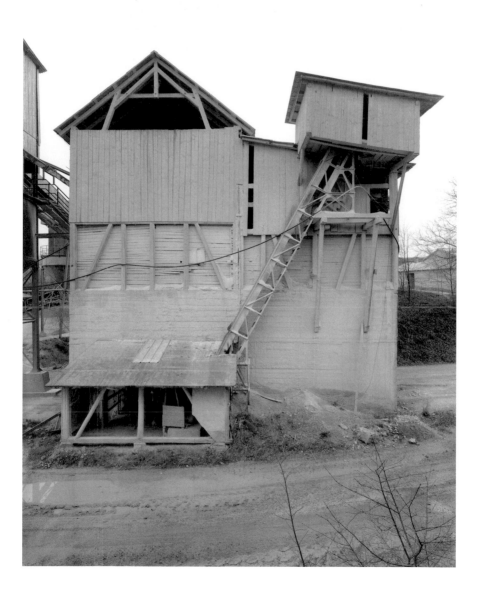

53

Steinbrecher für Kies. Stone Breaker for Gravel. Concasseur de gravier
Günzburg, D 1989

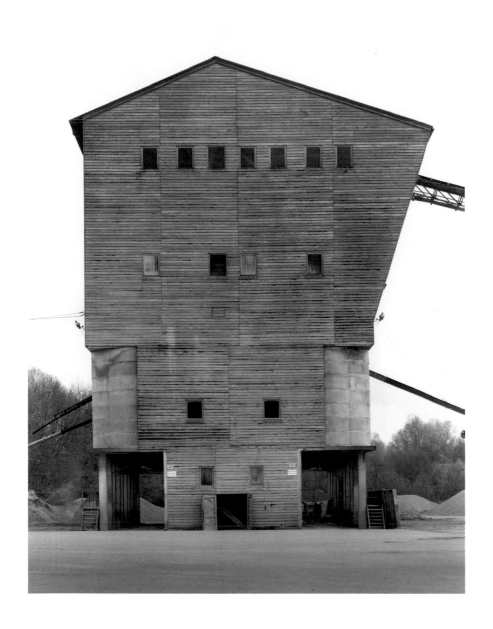

54
Steinbrecher für Kies. Stone Breaker for Gravel. Concasseur de gravier
Fürstenfeldbruck, D 1988

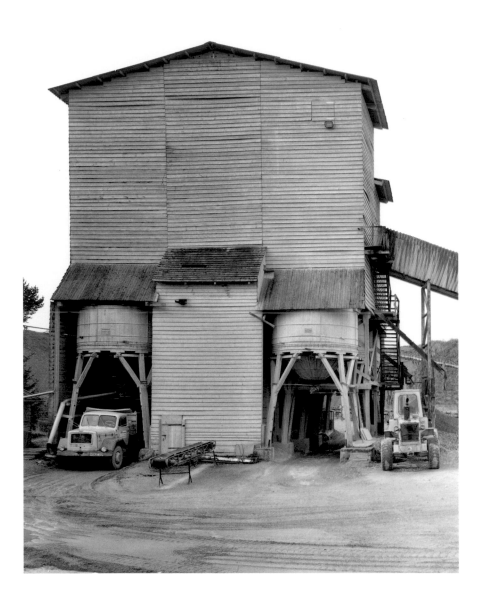

55
Wasserturm. Water Tower. Château d'eau
Luxembourg, L 1989

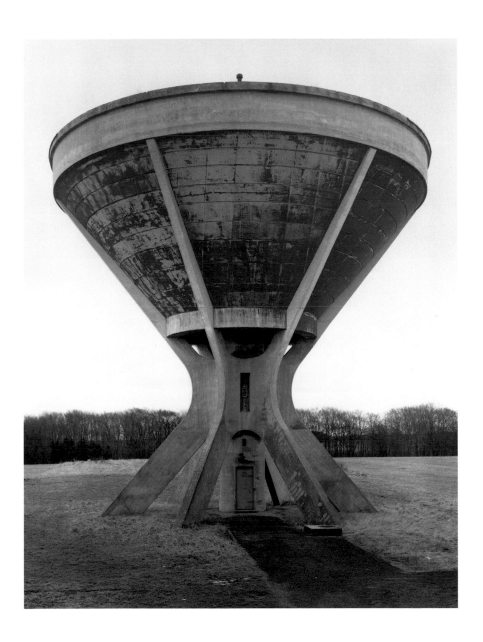

56
Wasserturm. Water Tower. Château d'eau
Neville Island, Pittsburgh, USA 1980

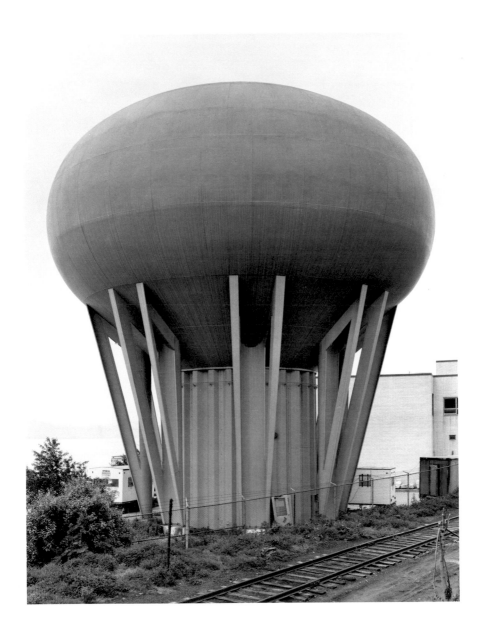

57
Wasserturm. Water Tower. Château d'eau
Findlay, Ohio, USA 1977

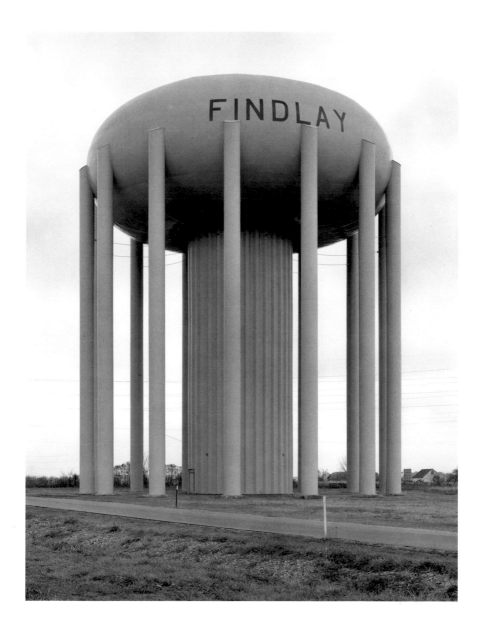

58

Wasserturm. Water Tower. Château d'eau

Verviers, B 1983

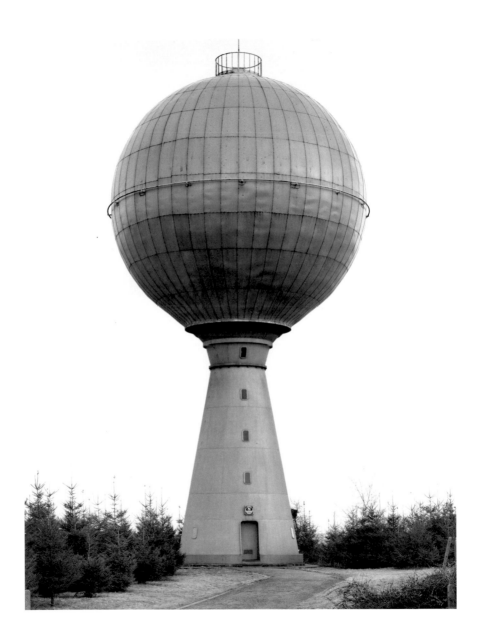

59

Wasserturm. Water Tower. Château d'eau
548 West 22nd Street, New York, USA 1989

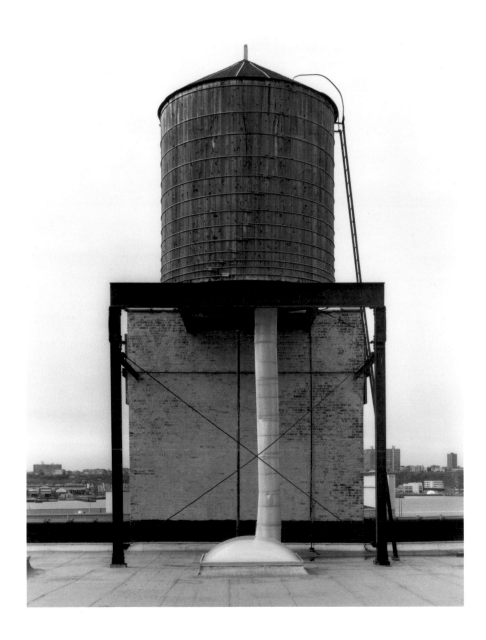

60
Wasserturm. Water Tower. Château d'eau
Bad Kreuznach, D 1980

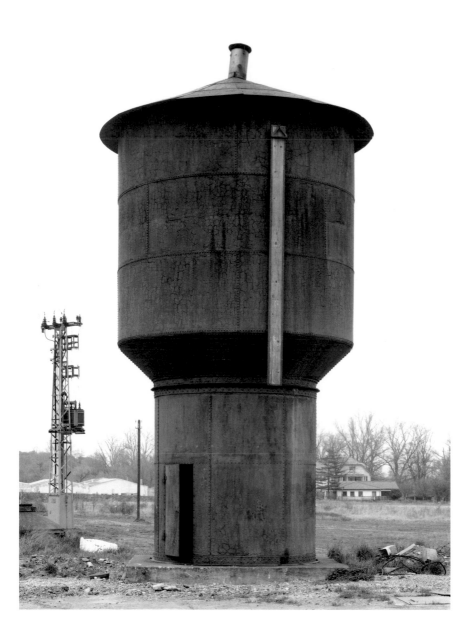

61
Wasserturm. Water Tower. Château d'eau
Oberhausen, D 1967

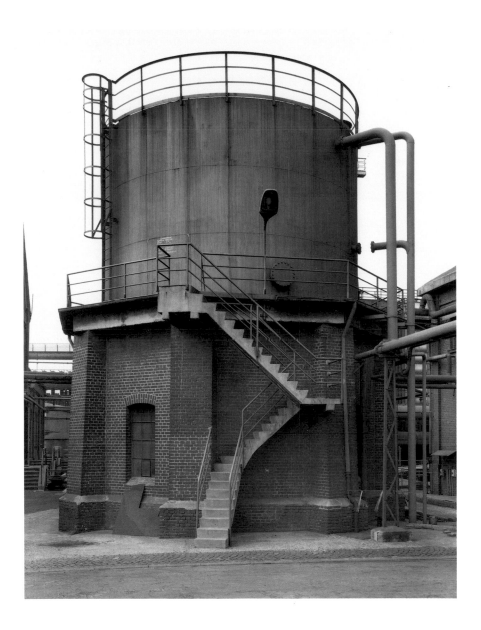

62

Wasserturm. Water Tower. Château d'eau
Mannheim, D 1978

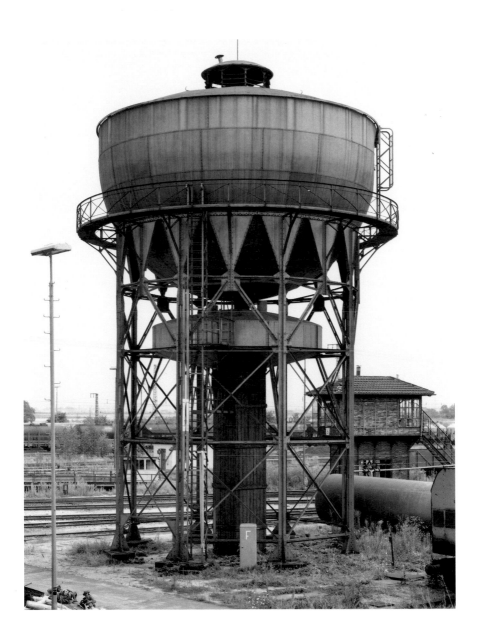

63

Wasserturm. Water Tower. Château d'eau

Fulda, D 1979

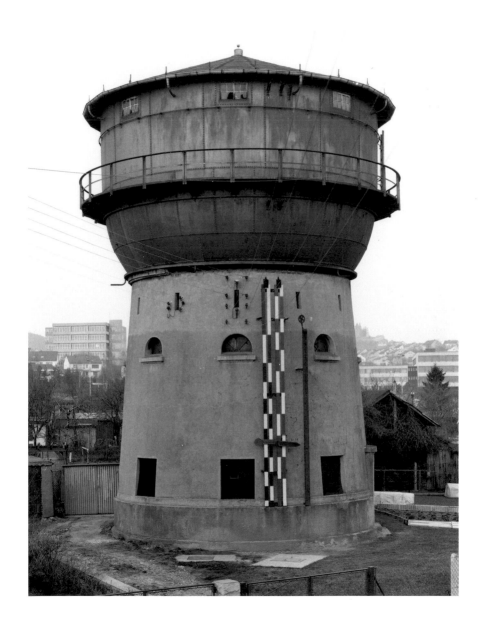

64

Wasserturm. Water Tower. Château d'eau
Crailsheim, D 1980

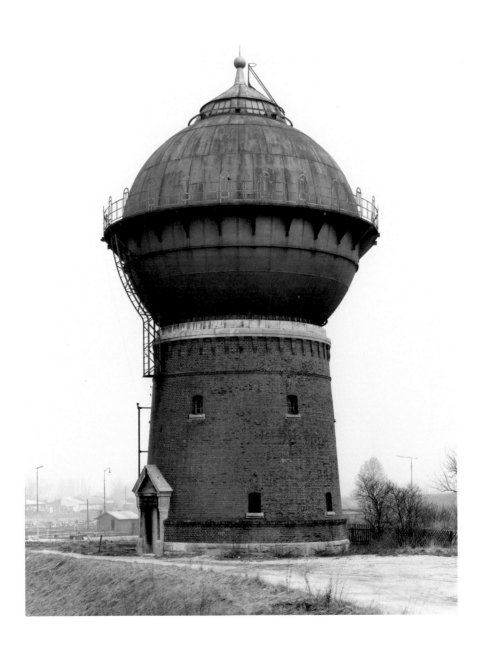

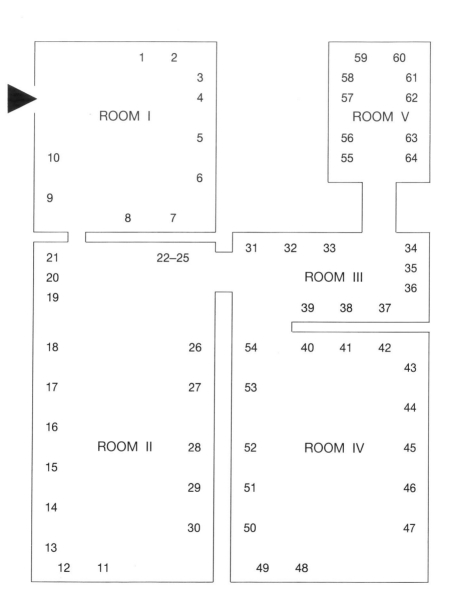

List of Plates

ROOM I
COOLING TOWERS

1 Steel Plant, Ebbw Vale, South Wales, GB 1966
2 Zeche Auguste Victoria, Marl, Ruhr, D 1967
3 Stahlwerk, Hagen-Haspe, D 1996
4 Zeche Schalker Verein, Gelsenkirchen, Ruhr, D 1982
5 Mons, Borinage, B 1967
6 Neunkirchen, Saar, D 1979
7 Zeche Ewald Fortsetzung, Ruhr, D 1985
8 Zeche Mont Cenis, Herne, Ruhr, D 1965
9 Penallta Colliery, Caerphilly, South Wales, GB 1966
10 Zeche Concordia, Oberhausen, Ruhr, D 1967

ROOM II
BLAST FURNACES

11 Youngstown, Ohio, USA 1981
12 Ensley, Alabama, USA, 1983
13 Johnstown, Pennsylvania, USA 1980
14 Cleveland, Ohio, USA 1986
15 Dillingen, Saar, D 1987
16 Rombas, Lorraine, F, 1984
17 Rombas, Lorraine, F, 1984
18 Rombas, Lorraine, F, 1984
19 Boel, La Louvière, B, 1985
20 Boel, La Louvière, B, 1985
21 Terre Rouge, Esch Alzette, L 1979
22 Völklingen, Saar, D 1986
23 Völklingen, Saar, D 1986
24 Völklingen, Saar, D 1986
25 Völklingen, Saar, D 1986

MINEHEADS

26 Puits Lens No. 7, Wingles, F 1967
27 Zeche Waltrop, Waltrop, Ruhr, D 1982
28 Ryhope Colliery, Sunderland, GB 1968
29 Zimmermann Coal Co., Ravine, Pennsylvania, USA 1978
30 Copperhill Mine, Central Shaft, Ducktown,
 Tennessee, USA 1983

ROOM III
HOT BLAST STOVES

31 Stahlwerk, Ilseder Hütte, Hannover, D 1984
32 Stahlwerk, Duisburg-Meiderich, D 1986
33 Stahlwerk, Duisburg-Meiderich, D 1986

SPHERICAL GAS TANKS

34 Wessling, Köln, D 1983
35 Wessling, Köln, D 1983
36 Wessling, Köln, D 1983

MULTIPLE SECTION GAS TANK

37 Pulaski Bridge, Jersey City, New Jersey, USA 1981

SPIRAL-GUIDED GAS TANK

38 Tonyrefall, South Wales, GB 1973

PISTON-TYPE GAS TANK

39 Zeche Minister Stein, Dortmund, D 1987

ROOM IV
GRAIN ELEVATORS

40 Van Wert, Ohio, USA 1977
41 Van Wert, Ohio, USA 1977
42 Lowell, Indiana, USA 1977
43 Wooster, Ohio, USA 1987
44 Bluffton, Ohio, USA 1987
45 Bluffton, Ohio, USA 1987
46 Smithville, Ohio, USA 1987
47 Elliot, Illinois, USA 1983
48 Strasbourg, F 1989
49 Briey, Lorraine, F 1985

STONE BREAKERS FOR BASALT

50 Mayen, Eifel, D 1987
51 Nisterberg, D 1987
52 Schwäbisch Hall, D 1989

STONE BREAKERS FOR GRAVEL

53 Günzburg, D 1989
54 Fürstenfeldbruck, D 1988

ROOM V
WATER TOWERS

55 Luxembourg, L 1989
56 Neville Island, Pittsburgh, USA 1980
57 Findlay, Ohio, USA 1977
58 Verviers, B 1983
59 548 West 22nd Street, New York, USA 1989
60 Bad Kreuznach, D 1980
61 Oberhausen, D 1967
62 Mannheim, D 1978
63 Fulda, D 1979
64 Crailsheim, D 1980

Chronology

1934 Hilla Wobeser is born on 2 September in Potsdam. After being trained as a photographer, she works as a commercial photographer in Hamburg and Düsseldorf.

1957 Moves to Düsseldorf

1958–61 Studies and sets up a photo department at the Staatliche Kunstakademie in Düsseldorf

1931 Bernhard Becher is born on 20 August in Siegen.

1947–56 Studies at the Staatliche Kunstakademie in Stuttgart with Karl Rössing

1957 Takes his first photos of industrial buildings

1957–61 Studies typography at the Staatliche Kunstakademie in Düsseldorf

1959 Begins working together with Hilla Wobeser

1959–63 Photos of industrial sites and buildings in and around Siegen

1961 Hilla Wobeser and Bernd Becher marry.

1961–65 Photos taken primarily of the industrial sites in the Ruhr Valley and in Holland

1963 First photos taken of mines in the Ruhr Valley, cement works in southern Germany and lime works in Holland.

1964 First photos taken of the industrial regions in Belgium, France and Luxembourg

1965 First photos taken of mines in England, Wales and Scotland.

1966 The Bechers receive a scholarship from the British Council to work for six months in England.

1966-67 Photos taken in France and Luxembourg

1968 Photos taken in the United States

1970 Photos taken in Belgium

1972–73 Guest lectures held at the Hochschule for bildende Künste in Hamburg

1974 Photos in the United States

1974–89 The Bechers continue their work in the industrial regions of Western Europe.

1976 Bernd Becher is appointed Professor of Photography at the Kunstakademie in Düsseldorf.

The artists live and work in Düsseldorf-Wittlaer. Since 1963 their work has been included in numerous individual and group exhibitions in Europe, the United States and Japan. In 1990 they received the sculpture prize at the Biennale in Venice.

Selected Bibliography

Framework Houses of the Siegen Industrial Region, Munich 1977
Fördertürme, Chevalements, Mineheads, Munich 1985
Gas Tanks, Munich 1993
Water Towers, Cambridge, Massachusetts 1990
Blast Furnaces, Cambridge, Massachusetts 1990
Typologies, Munich 1990
Pennsylvania Coal Mine Tipples, Munich 1991
Industrial Façades, Cambridge, Massachusetts 1995
Mineheads, Cambridge, Massachusetts 1997